Sage & Spirit

A Book of Poems by
Jet Widick

HANDLETTERING AND ILLUSTRATION BY
KIMBERLY 國子 TAYLOR-PESTELL

This book is dedicated to the heroes, champions, spirit lifters, sunshine bringers, soldiers of life, the brick layers and cathedral builders... all who live deep in my heart and soul.

Introduction and poetry copyright © 2017 by JET WIDICK.
Illustration and hand lettering copyright © 2017 by KIMBERLY K. TAYLOR-PESTELL.

ISBN 9781088191316. Hardcover, second edition printing: June 2023.

Creative direction and design by Kristen Alden.

NorthCoast Post, LLC
420 N. Third Street
Marquette, MI 49855

www.northcoastpostmedia.com

PREFACE

by Kimberly K. Taylor-Pestell

A COMING of SAGE

There are projects that stem from your own dreams and come to be out of your own making. And, there are others that begin with the dream of another who bids you to imagine and partake in something unexpected—something that you cannot create on your own, but only in partnership with others. I have found that these are the sorts of experiences that bring about a special form of growth that is both organic and lasting.

When Kristen contacted me about our first book, *Sage Words*, I was hesitant to venture into an area in which I might not be able to deliver. I was a new artist who had only just begun to identify as one and had yet to explore the wonders to be found in illustration. It is an amazing occurrence when someone can see something in you that you haven't encountered yourself.

Making art in any form is, by nature, a very personal endeavor. When creating on your own, you can fail in the privacy of your own page and, if you wish it, only you will be witness. Working with others, however, comes with transparency from the onset. Everything you create is seen in its most raw form, when it is furthest from completion.

Because of this, collaborations must center on trust—trust in a mutual dedication to the process and respect for each other throughout. Gentleness, patience and honesty allow space for productive brainstorming, creative freedom, constructive guidance and celebrating along the way.

I like to say (with a cheeky grin) that working on the *Sage* books has been "a coming of sage," and it is true. Being one part of this trio and working alongside such intentional, passionate artists has stretched my self-set limitations, invoked in me a deep love of illustration and taught me how meaningful collaboration can be.

My warmest gratitude to Jet and Kristen for sharing their art with the world and inviting me to be part of it. May *Sage Spirit* bring you as much joy and light as it has gifted us.

INTRODUCTION

My poems began with something as simple as a toast. I started practicing poetry in the way people write speeches for an inaugural dinner. I was dedicated.

Early on, I took a high school speech class and was overcome with panic. I didn't know the real fear of sharing my thoughts—until I took that class.

It was like a light switch flipped. First, it was the foyer lights, then the living room lights, and then the whole place was lit up and beaming! I honestly felt my heart pounding and a sincere tap on the shoulder from my muse, my angels, and God saying to me, "It's okay, Jet. Say it."

The initial chain reaction of my poetry and art amalgamation began with my son's bicycle accident. Then, it was forest bathing and ten straight full-day hikes in Vancouver followed by the trails and backroads of Vail Colorado to Laredo Mexico,
and back home again to the Sunshine State. It was stepping away and into nature that gave me space and opened my mind to speak up, and write.

I've come a long way since then. I'm bolder, more fearless and more vulnerable. A young warrior.

I took the leap and began with *Sage Words*—my moment of fortitude! And now, here along with Kimberly and Kristen, I introduce *Sage Spirit*, my second passion project with these two dear friends for whom I have a great admiration and respect.

If *Sage Words* is our cautious and diligent firstborn, *Sage Spirit* is our brave, spirited child on a journey for self-discovery. Similar to introducing a baby into the world, Kimberly, Kristen and I feel that *Sage Spirit* is a part of us. When you begin a passion project like this, the first thing that

comes to mind is how can we possibly love this collaboration as much as we loved making *Sage Words*? And then, the more we proceed with focus and dedication, the more love flows from within. God is truly in the details.

Up to the point when we worked together on completing *Sage Spirit*, the three of us had never even been together in the same room, which is astounding to me. But, this process works because Kristen takes the direction of this project seriously. She gets the visual rhythm, balance and nuance, along with the accents, height and cadence of the poems, and manages the project with incredible grace. Then, combine her fastidious skill sets and big picture vision with Kimberly's talent and creativity, and all the pieces beautifully fall into place.

I have always had intense gratitude—for everything. I love the precious people in my life and want to celebrate them. Their presence are presents. Life GIFTS!

To everyone and everything that has captured my heart with everlasting beauty, it has been a delightful experience to create, share and participate in the making of this book.

I love you
You make my day,
My world brighter,
Instead, I will toast you
It's much lighter.

There you have it—a message turned into a toast, made into a poem—from hikes in nature to more poems that became a book, then another. From the deepest part of my being... because of you, I'm beaming.

xo ~jet

My PRESENT

You are my present
I love all that you represent
outdoors and sunshine
peace, quiet and feelin' fine
You appeared out of nowhere
Without you, I feel a slight despair
Like I need mountain air
It's not good when I'm here and
you're there
When I know you'll be back soon,
I work harder, better

I know it's almost June
Sun, the stars and the moon...
whatever it takes
sand dunes, mountains,
rivers, lakes
to be around what you
REPRESENT

because I'm
100 PERCENT SURE
YOU WERE
HEAVEN SENT

TRUE HERO

To my HERO that I see:
For many years, you pass by me
You move to the beat of your walking stick
As my champion, you, I pick
Your STRENGTH as you go on your way,
Is inspiring to me every day
My ADMIRATION for you is strong and TRUE
You're on time, you never miss your cue
Your FORTITUDE is huge and MIGHTY
Your step is SOFT and SPIRIT, SPRITELY
I wish for happy things for you
Hope you are never sad or blue
You remind me to TAKE IN all I see
Appreciate Earth's BEAUTY constantly
I'm doing that for you and me
You're not just the blind man with the walking stick
You're the TRUE SOUL who will never quit !

FOR the SEA... iNTO SPACE...

THIS MEMORY, I CAN NOT ERASE
YOUR INTELLIGENCE is STUPENDOUS
YOUR PRESENTATIONS, TREMENDOUS
YOUR KINDNESS, ENDLESS
YOU ARE ROLE MODELS,
DIGNIFIED AND CLASSIC
YOUR LOVE FOR LIFE IS GIGANTIC
YOUR ENERGY is ELECTRIC
YOUR FOUNDING FATHERS' KARMA,
INTERCONNECTED
WHAT YOU HAVE TOGETHER IS
PERFECTED AND DEEPLY RESPECTED

a strong squeeze to your bicep
means sorry to bother you, I need you
to intercept — it's important
because I need your assistance
— from me there will be —
no resistance
because you're the best thing of
my existence
please rescue me, I'm simple, it's easy
I'll be your dream come true
— you'll help me not feel —
so blue — because you're the
best thing that I have ever seen
we'll wear our boots and
blue jeans — put bourbon
— in our canteen —
go where the sun beams

TRUE NOBILITY and STICKING UP for others
done RELENTLESSLY ← we watched GENEROUS
mentors do it EFFORTLESSLY ♥ it's the
way it is SUPPOSED to BE ← take the
HIGH ROAD, honorable comes NATURALLY
♥ a way for the WORLD to BE ← for
all ETERNITY ♥ respect INDIVIDUALITY,
all DIFFERENT tastes and UNIQUE qualities
feeling FREE and happy EASILY ← there are
no days to waste ♥ by your side NEVER SWAY
i like you AS YOU ARE, never change ←
here for all the GOOD STUFF and aches and pains
PICK you UP when it rains ♥ i'll take the wheel
stay on course, help not cross the lane ←
SAVE YOU if you start to drown ♥ try to NEVER
let you down ← counting on me because
you KNOW i'm taking STICKING UP seriously
make a rock solid FOUNDATION ♥ full of true

ADORATION as you build your DREAMS, your own CREATION ← not afraid of sharks in LIFE or SEA ● swim against the current FEARLESSLY ← because you know i'm always going to STICK UP for thee ● she for she, or He for He ← no difference, it's DIVERSITY STANDING UP for you, and you for me ● that's how life is meant to be ← aim for advocacy ENDLESSLY make life BETTER by loving TIRELESSLY ● speaking up, shedding light on HOW IT'S DONE ← that no one is ever SHUNNED ● working for NO GUNS! taking CARE of YOU when you're sick ← THERE for YOU if you're in too DEEP ● when life is piled in a heap ← to be STRONG, try not to weep ● get some REST now, go to SLEEP ← have sweet dreams of me STICKING UP for you, and i will of YOU for ME ● and each NEW DAY, we spread GOODNESS and everlasting TRUE NOBILITY ←

let the WORLD SEE...

this is
HOW it HAS to BE

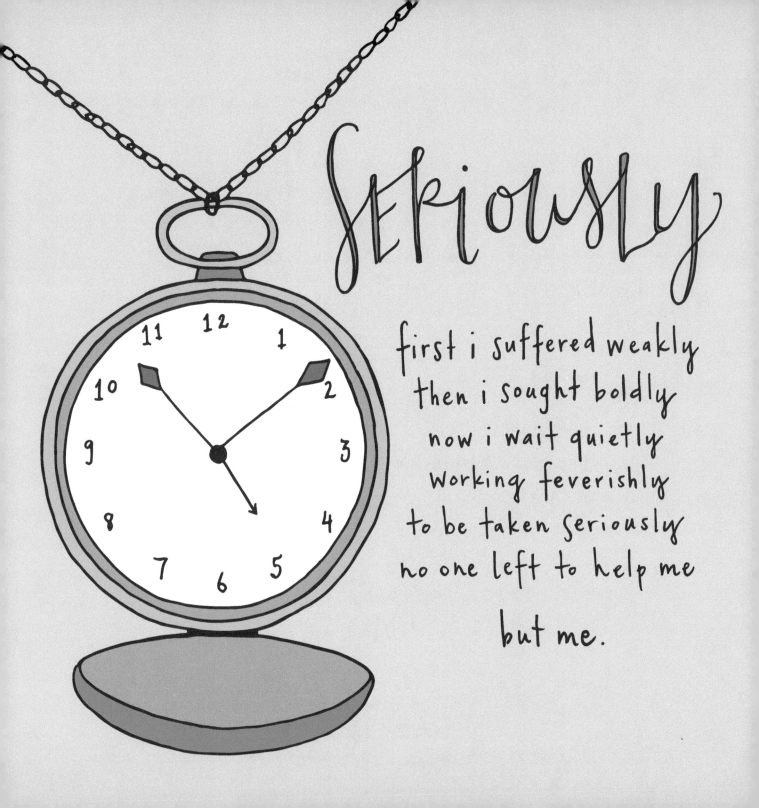

seriously

first i suffered weakly
then i sought boldly
now i wait quietly
working feverishly
to be taken seriously
no one left to help me

but me.

Sunlight to candle lights
out the door, coffee pass
to half-full wine glass
happy when I go to sleep
smiling when the morning peeps
new day 'til night falls
grateful from early morning
until my pillow calls

Peaceful Heart

i was FALLING and you CAUGHT me
you made it look easy, knowing nothing
and EVERYTHING
no judgments is what you bring
i got up kickin' and screaming
FIGHTING for what i BELIEVE in
now watch me beamin', i feel like
i'm DREAMIN' because you are a
"CATCH"ER
now that i'm caught, i can go for what i'm after

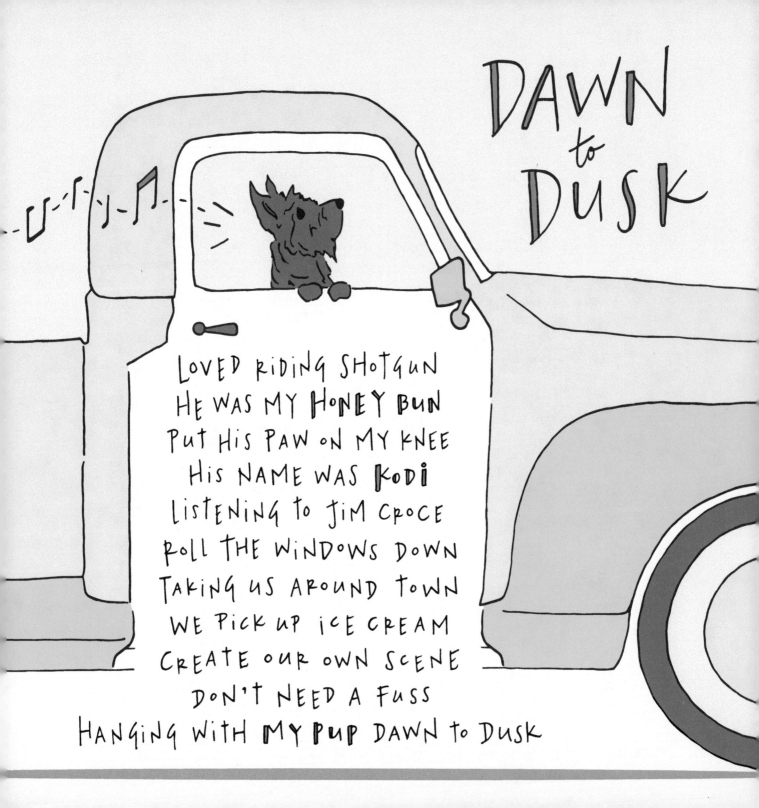

Want to have some tea with me?
Sit outside beside the sea
Lean back in your comfy chair
Let the wind flow through your hair
Feel the Sun's warmth on your skin
Tell me everything... just begin
I'm not moving from this place
Watch the smile on your face
Let the minutes turn to hours
Watch the birds and see the flowers
Cares melt away, you say something funny
I'm sipping tea with my honey

Tea

THE CRAVING FOR SIMPLIFICATION

COMES FROM A MUTATION OF OUR

NATION

INTO A PLACE OF OBSESSION WITH

COMMUNICATION

A FASCINATION WITH SENSATION

THE ADDICTION TO NOTIFICATION **VIBRATION**

A FIXATION

WITH A CENTRALIZED **LOCATION**

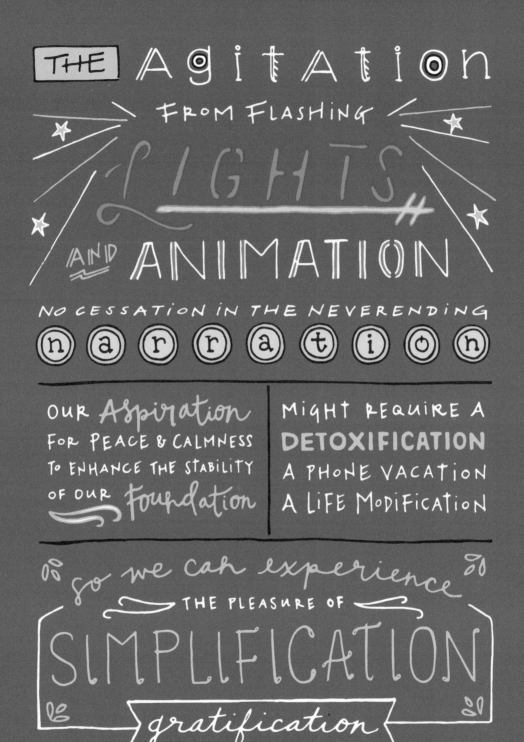

Run Away

I want to roam the planet with you
Hit the trail, take a week or two
Ride bikes down a hill
Take the snowmobiles out and chill
Summer, winter, spring or fall
Sleep in a tent, doesn't matter... your call
Tell me where we will go
I'll show up and only we will know
You and I will disappear
Turn off our phones and head into the stratosphere

ABOUT

JET WIDICK

Jet Widick is a writer, poet, and mother of two adult sons. A passionate explorer of inner and outer nature, her books are full of warmth, conscience, fortitude and whimsy, and cover a range of topics that reflect the lovely little things that make up our everyday lives—which so often go unnoticed—yet are truly the most important ones of all.

www.jetwidick.com

...

KIMBERLY 國子 TAYLOR-PESTELL

Kimberly Kuniko is the Nikkei American hapa artist and designer behind Lacelit, a paper goods company featuring endearing illustration, sentimental turns of phrase, and clever wordplay. She also loves exploring collage and mixed media art journaling and hosting cozy, virtual Guided Creative Retreats for creatives of all mediums that foster creativity, imagination, and storytelling in all its forms. She resides in what is now known as Monrovia, California, with her husband and their calico tabby cat.

www.lacelit.com

...

kristen alden

Kristen Alden is a writer, visual artist, and graphic designer with a passion for bringing creative ideas to life. After a few years on the West Coast and a couple more in the Upper Peninsula of Michigan, she now spends her time down south developing a vision for the everyday and an organized way of making things more beautiful.

www.kristenalden.com

GRATEFUL.

Angel wings
Allegiance on my shoulders
A pledge of love and devotion
To my heart holders